The Photography Project Pocket Deck

Your Shoot List and Pocket Guide of Inspiration

Toni Hayes

Table of Contents

Project Ideas	3
Places to Photograph	4
The Project Deck	5
January Shot List	
February Shot List	
March Shot List	
April Shot List	
May Shot List	
June Shot List	
July Shot List	
August Shot List	
September Shot List	
October Shot List	
November Shot List	
December Shot List	
Occasion Themed Shoots	
Styled Shoots	
Object Themed Shoots	
Inspired By Shoots	

Project Ideas

1. Roll the dice or pick a random item and try rendering it in super high contrast B+W

2. Combine two items from the deck and create a photograph

3. Take one item from the card and experiment with multiple light sources (flash, natural light, incandescent light)

4. Take an item from the deck and experiment with the thirds rule and put the item all over the grid

5. Find related items and photograph them as a set (example: pencil, scissors, hole punch)

6. Take an item from the deck and photograph it with two or more different lenses, focal lengths or cameras (i.e. Polaroid, dslr or 50mm, 18mm, etc.)

7. Photograph an item from the deck at multiple levels of detail (example: stem, petal, leaf, flower)

8. Take an item from the deck and photograph it but add smoke (dice with smoke)

Places to Photograph

1. Zoo
2. Museums of Science
3. Museums of Art
4. Local Park
5. Rivers or Local Ponds
6. Amusement parks
7. Your Backyard
8. Abandoned Places (check local laws)
9. Downtown
10. Libraries
11. Municipal buildings
12. Farm stands
13. Grocery stores
14. Beach
15. Restaurants
16. Walking trails
17. Monuments
18. Cemeteries
19. Pet store
20. Flower shop

The Project Deck

paper clips
before and after
black and white
blue
body part
books two
candy
celebration
close up
clouds
comfort

faceless portrait
five
flowers
food
frame in a frame
green
hands
high angle
letters
light painting
long exposure
love

low angle
metallic
moon
morning
music
nature
orange
red
reflection
round
Self portrait
shadows

shine
red shoes
silhouette
soft
something old
something tiny
spooky
sweet
tattoo
texture
three
toy people

unwrapped
water dripping
white
yellow
storyboard a movie
chains
currently reading
street signs
broken
environment
into the sun
odd number

machinery
animals
f/16
heat
rust
negative space
solitary
lunchtime
transport
11'oclock
trees
centered

- street
- texture
- spice
- head shot
- enjoying life
- macro
- empty
- from above
- bright
- last
- thankful
- street photography

red
from down low
favorite color
movement
you
insects
fall
something funny
sharp
on my table
family
smoke

depth of field

moments

kitchen

colorful

cute

leaves

high iso

after dark

four levels of detail

bolts and locks

best part of your day

your reflection

happy things
grateful for
building
handwriting
breakfast
shadow
something you found
orange
sunset
garden
reflection
fun

looking down
favorite color
lunch
street signs
broken
color
breakfast place
in my bag
on the floor
how you feel today
open
odd number

somewhere you went
chair
stairs
inside your wallet
finger
1pm
sign
mail
circle
cold
younger you
sad things

big
last thing you bought
solitary
hair
tiny
bottle
head shot
something you drew
busy
something you dislike
flower
vegetable

photograph a process

zoo

metallic

9 o'clock

stranger

Long exposure

thanks

pet

bokeh

on the road

hands

shoes

red
halloween
eyes
pink
mom
celebration
sunshine
clouds
far away
upside down
close-up
plate

patterns
feet
morning
patriotic
blue
spooky
natural light
cup
fall
flowers
your addiction
mirror

flag
toothbrush
calm
dad
yellow
shadows
jump
green
heart
low angle
sun flare
Easter

family
technology
landscape
sunset
marbles
heels
glowing
neighborhood
5pm
colorful food
butterflies
up

sunglasses
red
funny
feet
moon
framed
fruit
candy
low light
dislike
window
through the window

well used
bedside
car
Christmas
snacks
key
catch lights
dead center
nuts and bolts
laughter
green
loud

letter tiles

doorway

stripes

smile

frozen

fork

person

passion

black

repetition

collection

trash

something you wore
where you relax
circle
toy
crayons
your name
kitchen sink
fur
playing cards
pins needles
10 things
flash light

pumpkins
muse
home
brown
reading now
fog
water
music
nature
weird clothing
night
through the lens

bridge
dew
candy corn
bad habit
blue
harvest
where you sleep
caramel apples
commute to work
guilty pleasure
symmetry
stuff in your pocket

emotions
what you ate
happiness
scarecrows
sunrise
paisley
leaf stomping
crisp
monster
daily routine
hay ride
morning

something you made
ugly
junk drawer
grace
jack o lanterns
ice
pocket
drama
eyes
jump
inside your fridge
antiques

dominoes
wheels
wine
3:35pm
cupcakes
work related
smile
teacup
inside backpack
coffee
your day off
gear

on your desk

from a distance

surgery

money

sky

denim

bathroom

sleep

beer

stuff in a box

fireplace

teapot

singing
numbers
on the shelf
closet
something old
clock
inside purse
coffee beans
filthy
lipstick
tea
tropical fish

nail polish bottles
candlelight
kids
fabric
motion
warning
sunset
white
arches
sport
makeup
pop culture

chocolate

new you

together

fashion

business cards

origami

paved path

golf

pencils

horses

film

balls

fake beer ad

paper

cereal

knees

wine glasses

sushi

bocce

trail

beach

umbrellas

bowls

statues

hay bails
tags
advertisement
marbles
pond
meal prep
cameras
farming
coastline
swans
fake soda ad
wheels

mortar and pestle
rocks
3 things
envelopes
batteries
tools
books
lighthouse
keyboard
sunflowers
antique plows
elbows

string
wristwatch
barns
ring
walkway
naked
ice water
lace
cell phone
your favorite meal
your favorite books
magazine photo

album cover head
self-portrait in wigs
puddle reflection
page from a book
lobsters
army men toys
all your cameras
all your lenses
photo through nets
through the lens
sky view
wind in action

January Shot List

Snow
New Year's Decor
Wine Bottles
Balloons
365 project day 1
52 project week 1
12 project month 1
Resolutions
Party
Music
Freeze

February Shot List

Valentines

Presidents

Hearts

Red

Time Lapse Snow

Love

Flowers

Kiss

Groundhog Day

Blizzard

Winter Zoo

March Shot List

Green

Shamrocks

St. Patrick's Day

Irish theme

Beer

Basketball Brackets

Clocks

Spring Thaw

Flowers

Birds

Boots

April Shot List

Flowers

Easter

Eggs

Candy

Trees

Earth Day

Clogs

Baskets

Garden Tools

Farm

Sky

May Shot List

Flowers

Insects

Birds

Cinco De Mayo

Kites

Umbrellas

Woods

Rubber Boots

Gardens

Bird house

Trees

June Shot List

Bugs

Landscapes

Heat

Sweat

Carnival

Kids

Underwater

Running Race

Boats

Swimming

Candy

July Shot List

Fireworks

Red White Blue

Picnic

Bar B Q

Flags

Light streaks orbs

Fun

Balloons

Zoo animals

Beer

Cake

August Shot List

- Vegetables
- Fruit Trees
- Office
- Flowers
- Bugs
- Pick your own farm
- Apples
- Back to School
- Different color leaves
- Landscapes
- Orange

September Shot List

Back to School

Backpack

Learning

ABCs

123s

Books

Pencils

Paper

Leaf Peeping

Orange and Red

Yellow

October Shot List

Pumpkins

Orange

Halloween

Ghostly

Squash

Scary

Pomegranates

Pie

Harvest

Leaf Peeping

Hay

November Shot List

Turkey
Celebration
Gourds
Squash
Corn stalks
Pine
Snow
Xmas
Evergreen
Lights
Fire

December Shot List

Xmas

Religious

Santa

Red and White

Figs

Gifts

Bows

Mittens

Scarf

Fireplace

Cider

Occasion Themed Shoots

Birthdays

Weddings

Parties

Date Night

Dinner

Baby Born

Anniversary

Surgery

Picnic

Styled Shoots

Fake a Wedding
- Find a location
- Create a bouquet
- Set the table
- Use models
- Borrow a dress
- Get a cake

Use local vendors and upload images to a blog if you have one. Share with your vendors for great advertising.

Object Themed Shoots

Find an object that you like and keep it with your camera gear so that if there's nothing interesting in the foreground you have something to make the scene more interesting. This could be anything, an umbrella, a blue scarf, a red ball, etc. The possibilities are endless. It usually works out better if it's something that is portable or that you can keep in your car.

Inspired By Shoots

Pick your favorite movie and re-create scenes with photos

Find an ad that you like and recreate it or make a new one

Bring your favorite book to life with photos

Create photos that tell a story in a collage

Find More Inspiration and add to this list

www.ingramcontent.com/pod-product-compliance
Lightning Source LLC
Chambersburg PA
CBHW070432180526
45158CB00017B/1045